seashells

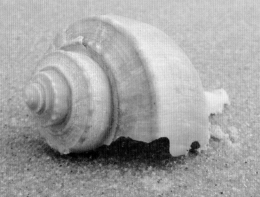

Also by Cindy Bilbao

Sea Glass

Sea Glass Seeker

seashells

CINDY BILBAO

The Countryman Press
A division of W. W. Norton & Company
Independent Publishers Since 1923

For information about permission to reproduce selections from this book, write
to Permissions, The Countryman Press, 500 Fifth Avenue, New York, NY 10110

For information about special discounts for bulk purchases, please contact
W. W. Norton Special Sales at specialsales@wwnorton.com or 800-233-4830

Manufacturing by Toppan LeeFung
Book design by Ashley Prine, Tandem Books
Production manager: Devon Zahn

The Countryman Press
www.countrymanpress.com

A division of W. W. Norton & Company, Inc.
500 Fifth Avenue, New York, NY 10110
www.wwnorton.com

978-1-68268-279-1

10 9 8 7 6 5 4 3 2 1

AUTHOR'S NOTE

Capturing images of shells while walking on the beach turned into an obsession for me after the editors at The Countryman Press asked if I would be interested in following up my books *Sea Glass* and *Sea Glass Seeker* with one about seashells. I had already spent many, many years photographing coastal vistas and sea glass, so photographing shells seemed like a natural next step for me.

I went into full recon mode, searching all the nooks and crannies in my house for the shells I'd picked up over the years. My family and I had moved several times, and I was afraid my shell collections might have gotten lost in the shuffle. I almost cried when I miraculously found the shells I'd collected on my honeymoon in Aruba more than 25 years ago.

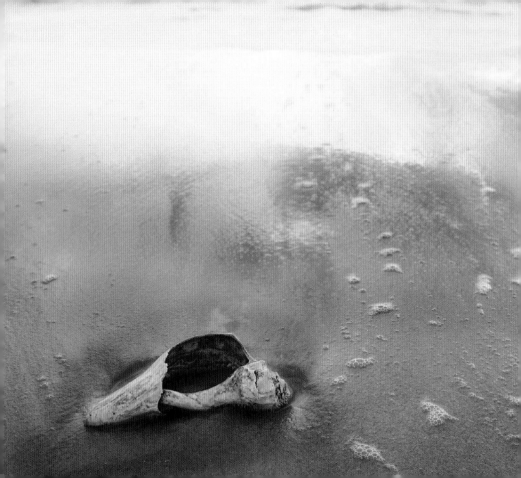

I also found the shells I'd picked up from a favorite beach in Maine; it was one of my getaway spots when we lived in the Berkshires years ago. My son was a baby then, and my daughter hadn't been born yet. Now she's going off to college and it's hard to believe all that time has gone by. We've since moved farther south, to Pennsylvania, and now I'm collecting shells from different regions like New Jersey and Delaware—perhaps someday I will dig these shells out too so I can fondly remember these adventures. And that's really what shell collections are—diaries of life's travels and collections of sentimental moments to cherish.

In all those years collecting shells, however, I never had the time to actively learn about them; I suppose that's why they hold such mystery. I'm sure I'm not the only shell collector who feels this way. And so, as I write this seashell book, my goals are

twofold. First, I'd like to help make your shell collection even more meaningful to you. You picked up and brought home that shell for a reason—it captured your attention in some way. You'll appreciate it significantly more when you understand just how amazing these bits of nature really are! Second, I'm a photographer, and the visuals I bring to you within this book set a mood. My intention is for you to feel like you're taking a peaceful, relaxing walk on the beach, looking for seashells as you go along. Part of the allure of these beauties is that they are found at the seashore, surrounded by such beautiful vistas that I would love for these photographs to encourage you to notice all the little things around the shells, such as foam from the water, or different colors of seaweed, or the changing colors of the sky.

After your "walk" through this book, I hope you'll feel a little more informed about the shells you encounter and will gain a greater appreciation for these treasures we find in the sand. I think what you will learn may surprise you—it did me.

I'm thankful to be given the opportunity to learn more about seashells and to focus my lens on this new and exciting topic, and I hope you enjoy the journey!

seashells

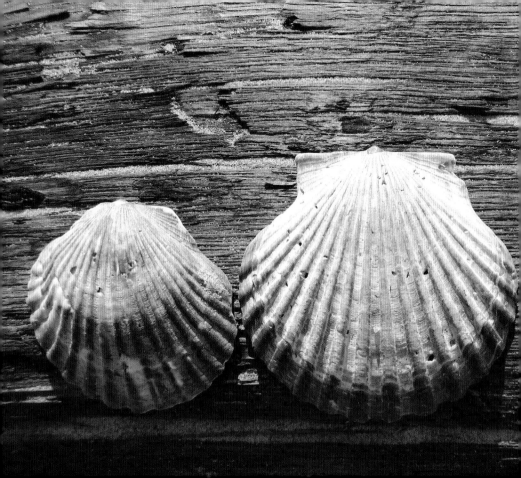

THAT SHELL YOU PICKED UP out of the sand is many things. It's the protective outer covering of an animal, an important part of the coastal ecosystem, a source of the delicious food we eat, a decorative item of beauty, a material for artisans to create with, and sometimes a highly prized collectible. Scientists have studied mollusks and their shells intently, and the results have helped them create innovative products that are beneficial to our modern society. In the past, shells have been used as currency, as tools, and as a colorful dye for clothing. There are thousands of different kinds of shells in all varying shapes, colors, and sizes.

11

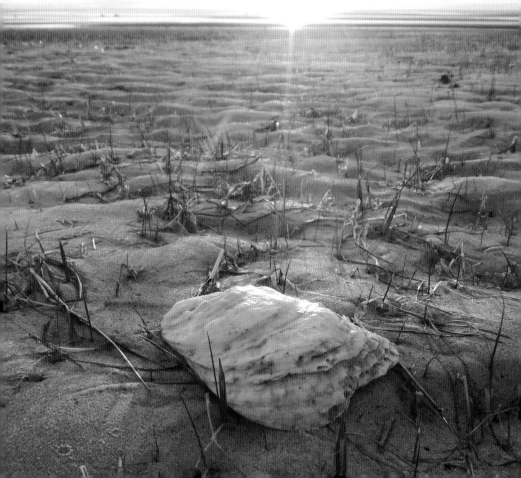

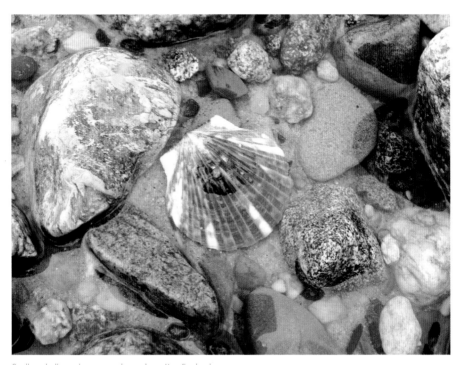

Scallop shell caught among the rocks in New England.

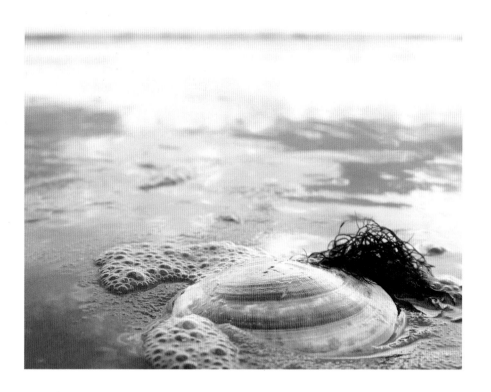

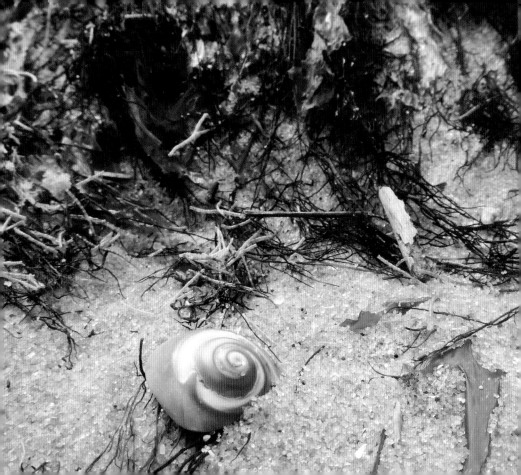

Seashells spark our interest in the natural world, and there is hardly a beachcomber who isn't fascinated by their allure and beauty. We love them because they offer a glimpse of that mysterious, watery world we cannot fully see from our vantage point on the sand. They are the very essence of the beach, and that's what inspires us to pick them up and save the ones that appeal to us. Each shell becomes a reminder of our time near the water. I'm sure that, like me, you've probably collected a few—or maybe even a few hundred! You certainly wouldn't be alone: over the course of history, there's evidence that shells have always been objects of fascination. When the ancient ruins of Pompeii were uncovered, an extensive shell collection was among the artifacts that were discovered. Archaeologists have found shells a very long distance away from their natural habitats, showing that at some point

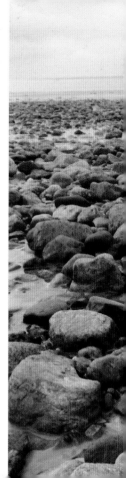

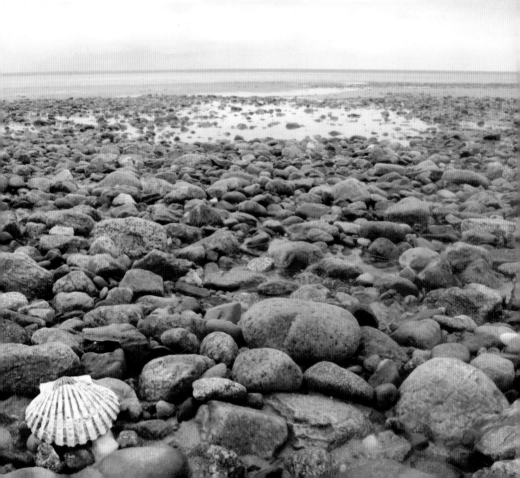

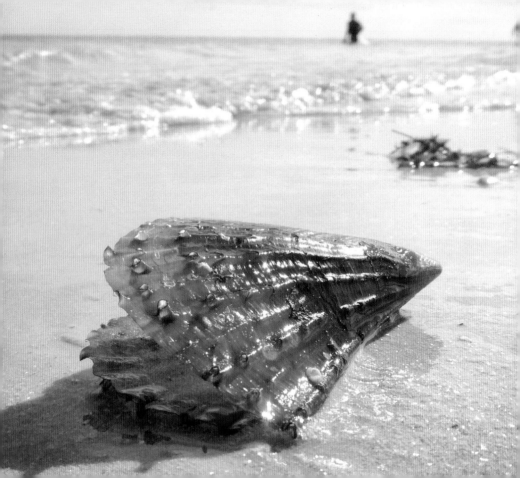

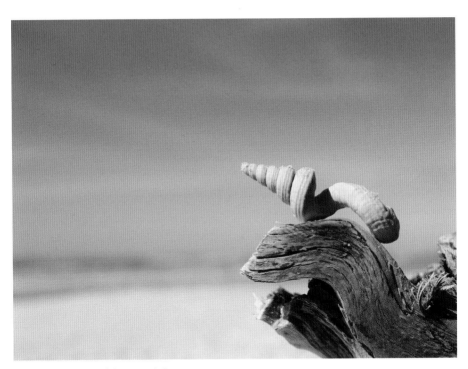

The interesting shape of the worm shell.

they were traded or used as currency. During the Renaissance, the scallop shell was often depicted in architecture and in art, and in the seventeenth and eighteenth centuries, European explorers brought shells back from their travels to distant shores. It was during the Victorian era, in the nineteenth century, that shell collecting became extremely popular, when people other than just the rich began admiring and acquiring them. And today, they are still widely collected and coveted.

right: A New England shoreline.

following page: It's very relaxing to spend some time at sundown examining the various shells that wash ashore. Make sure to enjoy the show of colors in the sky, too!

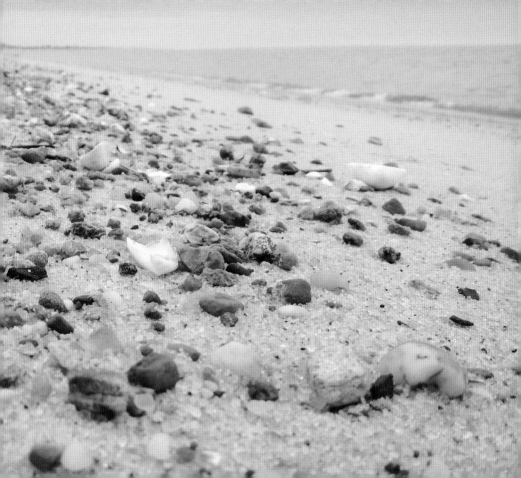

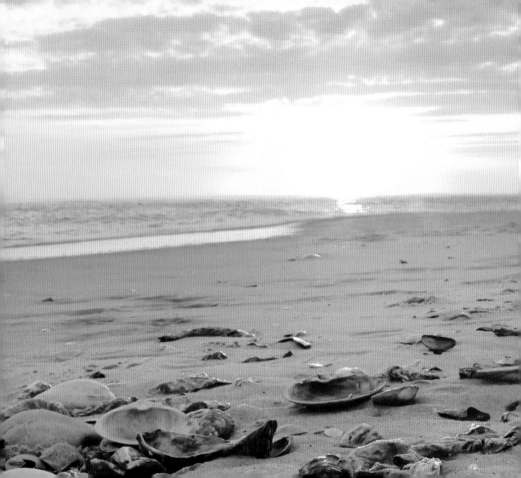

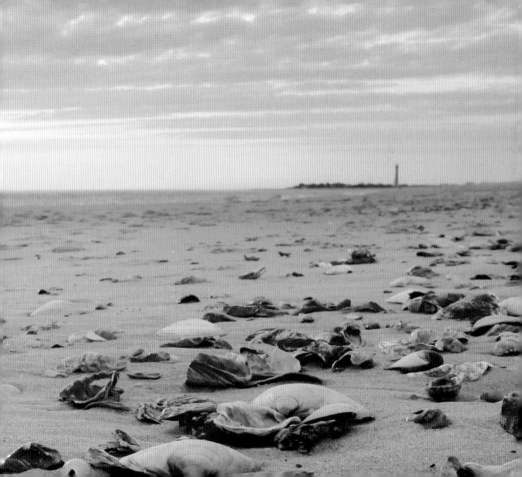

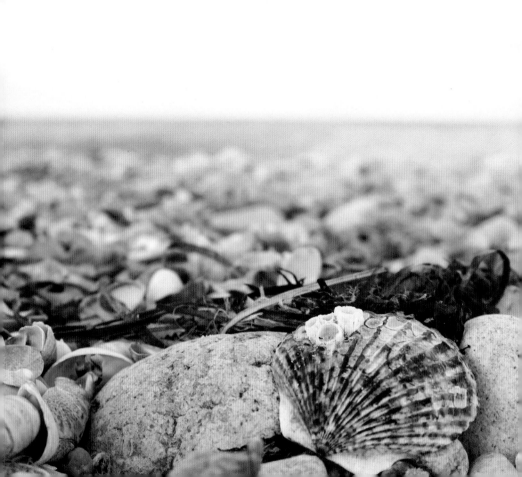

MOST SEASHELLS ARE ONLY spotted once they've washed ashore, so the casual beachcomber is left to wonder about the creatures that make and use them. What exactly IS a seashell, and what is its purpose? A seashell is the hard, protective outer covering of a marine animal called a *mollusk*. Unlike mammals, which are vertebrates with an internal skeleton, mollusks are invertebrates with a soft tissue body containing no bones. So a mollusk's shell serves as its source of protection—its exoskeleton—until it is no longer alive. With a few exceptions, a living mollusk will never be without its shell. And mollusks are always evolving and growing, so their shells

A scallop shell presides over a bed of slipper shells on a quiet evening on Martha's Vineyard.

25

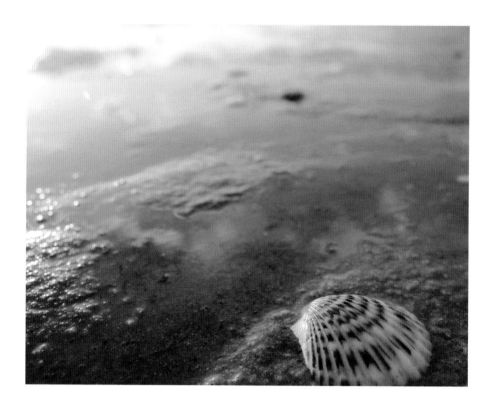

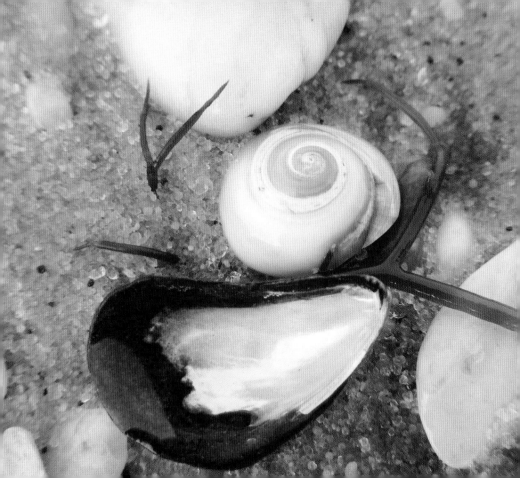

The Three Layers That Make Up a Seashell

1. Nacre Layer
2. Prismatic Layer
3. Proteinaceous Periosteum Layer

extend and expand throughout their life span. Then, after the mollusk dies, the shell remains behind and sometimes washes ashore, which is why we see so many of them on the beach.

Mollusks create their shells using materials from their environment. Calcium, carbon, and oxygen are the ingredients needed for the process, and these are found in the water where they live and the food that they eat.

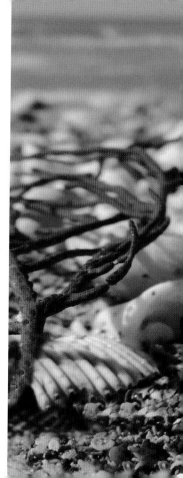

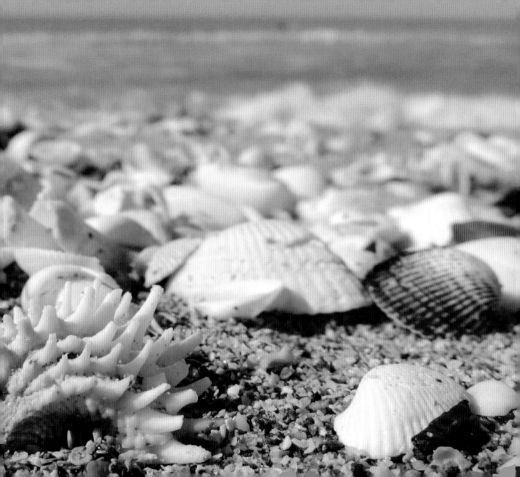

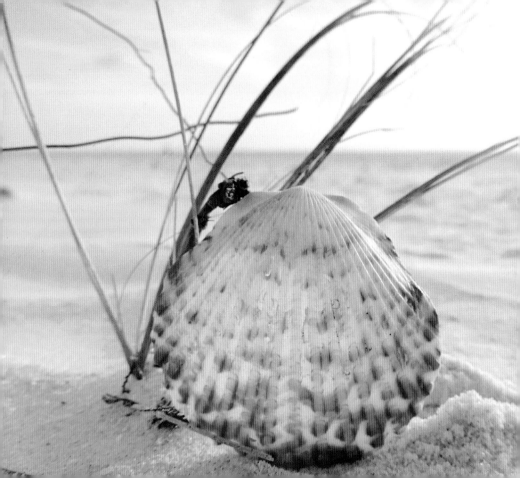

The way the [...]
fascinating proc[...]
as the *mantle*, c[...]
layer that surro[...]
secretes a mat[...]
in layers to fo[...]
it has to grad[...]
material. Th[...]
formed at th[...]
this area is called the *aperture*. [...]
are formed successively, so that each new layer is
created underneath the last layer as the shell grows.
The innermost layer, called the *nacre*, is smooth
and pearly, serving to protect the mollusk's soft
body from parasites and tiny irritating particles of
sand and grit. The middle *prismatic* layer is rich
in calcium, while the outermost layer, called the
proteinaceous periosteum, is made of proteins.

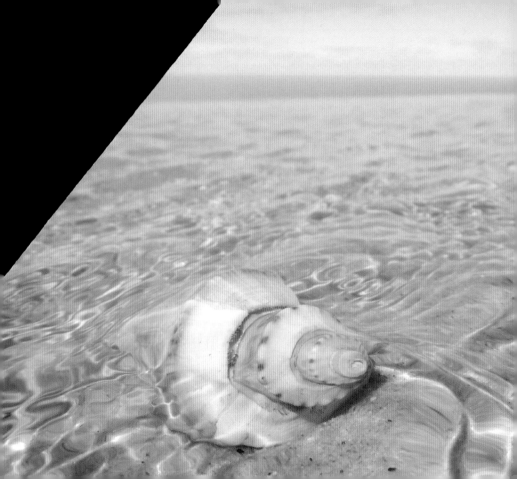

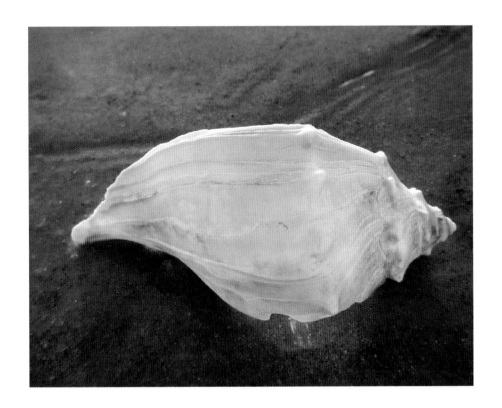

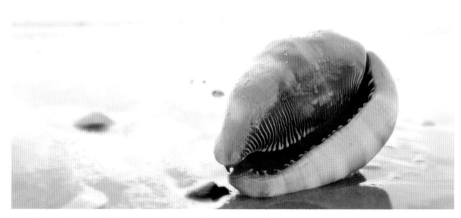

above: This is the beautifully colored underside of the helmet shell.

opposite: Ponderous arks

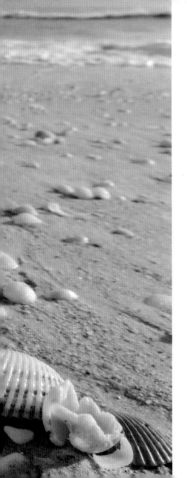

SCIENTISTS DON'T KNOW FOR sure just how many species of mollusks exist—each with its own unique type of shell—but they estimate it to be in the hundreds of thousands. In fact, the only animal group with more species than the mollusk is the insect! Experts believe that there are many more species of mollusk that have yet to be discovered because they live in extremely deep waters where humans have yet to explore. The Monoplacophora class of mollusk, which has a thin, single rounded shell, was thought to be extinct. But in 1952 a few specimens were discovered living in the depths of the ocean. They were given the name *Neopolina galathea*.

A buttercup lucine shell brightens up a cloudy beach.

37

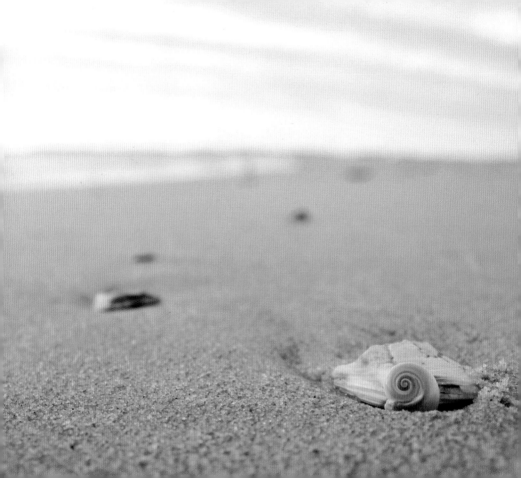

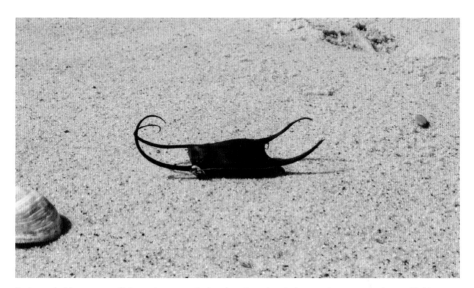

You've probably seen one of these objects on the beach and wondered what it is because it looks so odd—like a pillow with curly projections at the corners. It is not a seashell—it's a skate egg casing that contains the embryo of a skate, which is a sea creature related to rays and sharks. The hornlike projections extract oxygen from the water and expel waste. These egg casings are also called "mermaid's purses" or "devil's pocketbooks." For more interesting information, see page 143.

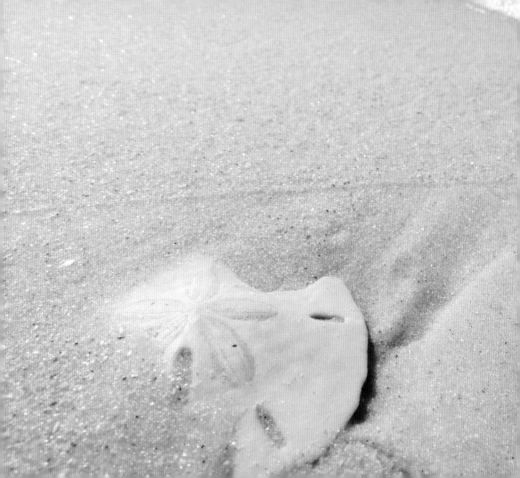

CONCHOLOGY
is the study of shells.

MALACOLOGY
is the study of the mollusks
inside the shells.

The many kinds of mollusks are divided into different classes: **gastropods**, snails with one coiled shell; **bivalves**, like mussels and clams, which have two connected shells; **Polyplacophora**, such as chitons, marine mollusks with an oval-shaped shell that looks a little bit like a turtle's shell; **cephalopods**,

Did you know that sand dollars are purple when they are alive?
Their decorative holes are used to ingest water.

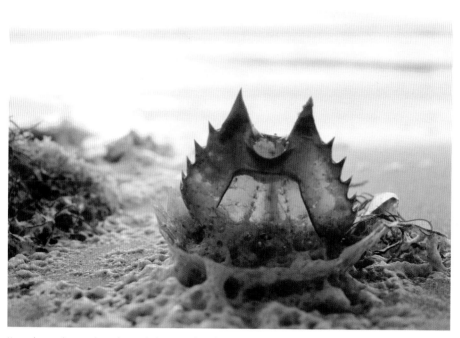

Horseshoe crabs grow by molting, which means that they will shed their outer shell in order to grow a larger one. Here you can see the interesting shape of the shell and its translucence.

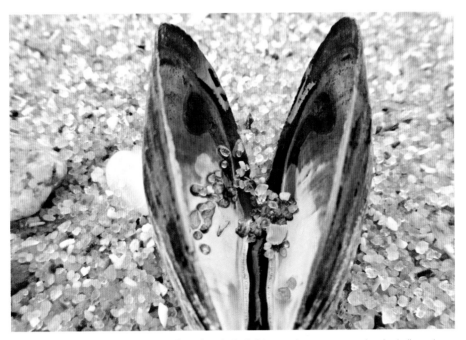

This blue mussel (a bivalve) still has both halves of its shells. Still damp with water, it created such a brilliant glow that I had to get a photo.

like squid, which have no shell; **scaphopods**, known as the *tusk shell*; and **monoplacophorans**, which live in the deep part of the ocean. There are a few other shell-housed animals living in the sea, but these are not classified as mollusks. Other creatures we may find on the beach include **echinoderms** such as sand dollars, sea stars, and sea urchins, and **crustaceans** such as horseshoe crabs, lobsters, and crabs, which, unlike mollusks, shed their shells.

The shells we see when we are walking the beach will usually fall into one of two categories: **bivalve** shells, which are comprised of two hinged shells that close to protect the mollusk inside, and **Gastropoda** shells, which consist of just one coiled shell that houses a large mollusk, like a snail.

Whelks and conchs are two popular shells that are found within the Gastropoda class of coiled shells. ✑

The knobbed whelk is the state shell of both New Jersey and Georgia.

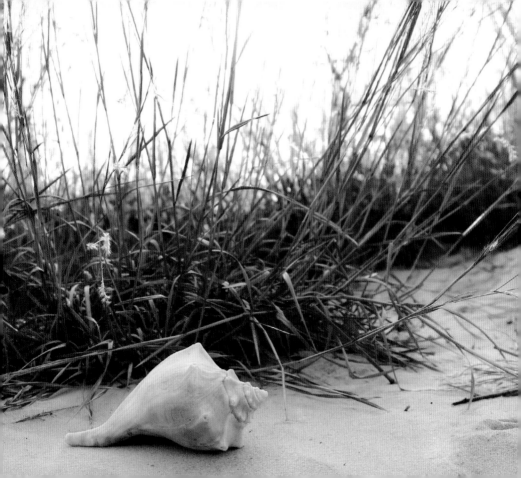

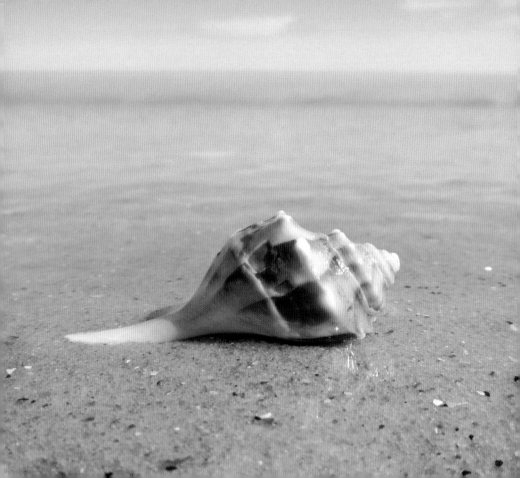

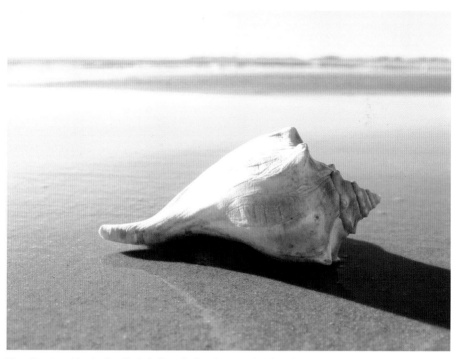

This old and sun-bleached knobbed whelk can be found on most beaches along the Atlantic Coast.

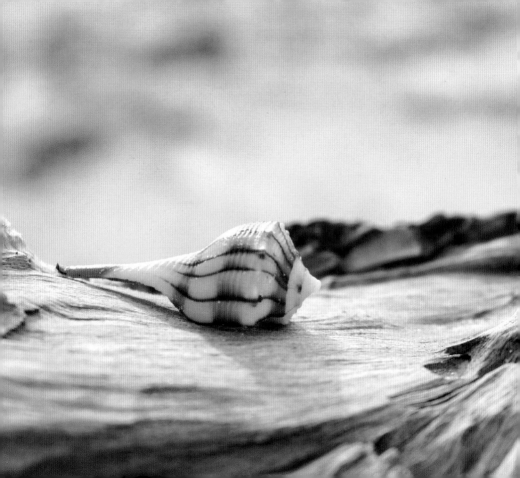

THESE SNAILS BUILD THEIR shells around a central axis. Whelks and conchs look similar, and people sometimes confuse them with each other, but here's an interesting difference: conchs (found in warm tropical waters only) are herbivores that feed on algae and vegetation, while whelks (found in both warm and cool waters) are carnivores that feed on meat such as other mollusks, crustaceans, and bivalves. When a whelk feeds on a bivalve, it has two ways to attack—it can use the lip of its shell to pry open the bivalve and gain access to the prey inside, or it can secrete a chemical from a gland that will soften an area of the prey's shell. The whelk can then chip and scrape at the weakened portion of the shell with its saw-like radula until a hole develops, so that feeding is possible.

49

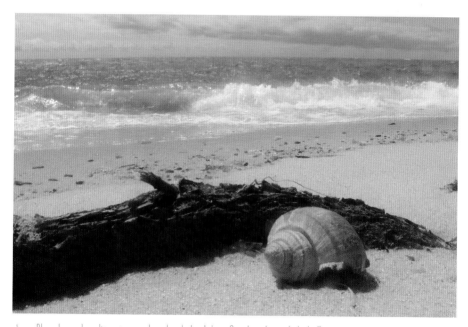

above: Blue sky and sunlit waters make a lovely backdrop for this channeled whelk.

opposite: Here you can see the oval-shaped operculum, which acts as a door that closes up the opening of the whelk shell, allowing the snail to retreat inside.

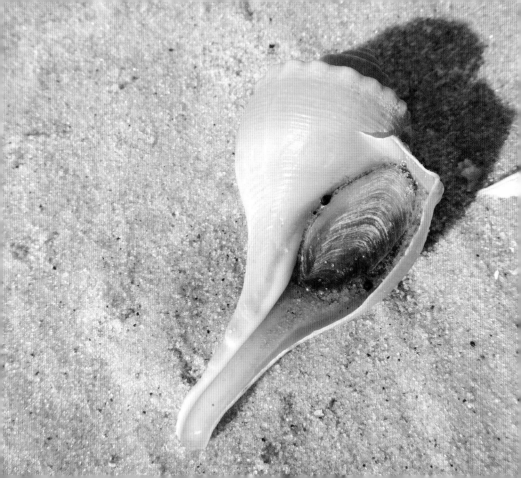

BECAUSE WHELKS BUILD THEIR shells around
a central axis, the opening of the shell—called
the *aperture*—will be located on one side of the
axis. This is known as "handedness." Most shells,
about 90 percent, will be right-handed, or **dextral**,
meaning the aperture will be on the right side of
the shell. The lightning whelk is an exception. It is
naturally **sinistral**, meaning its opening is on the
left side of the shell.

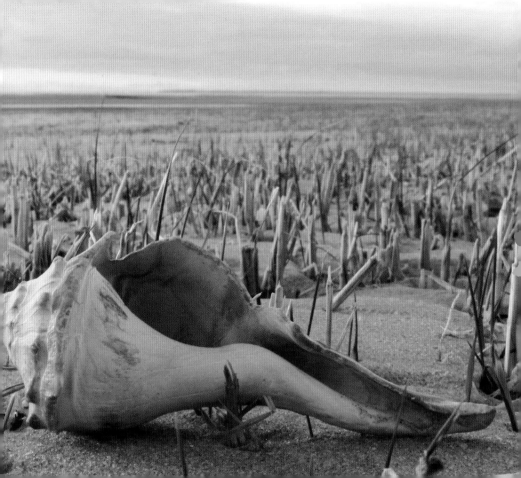

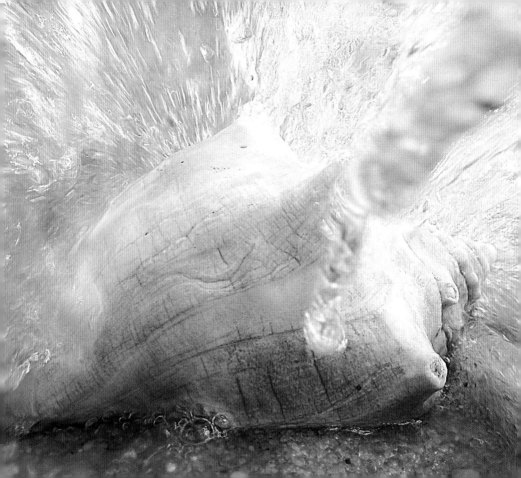

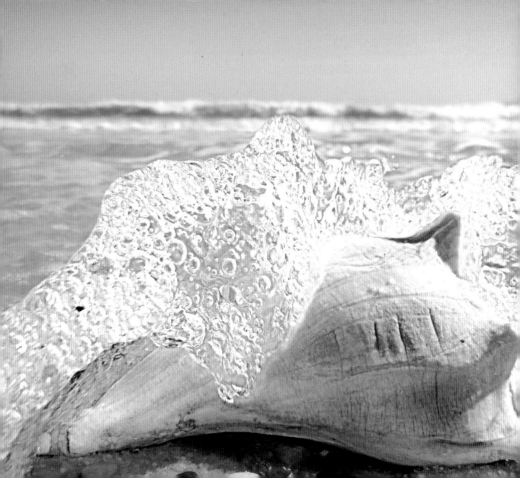

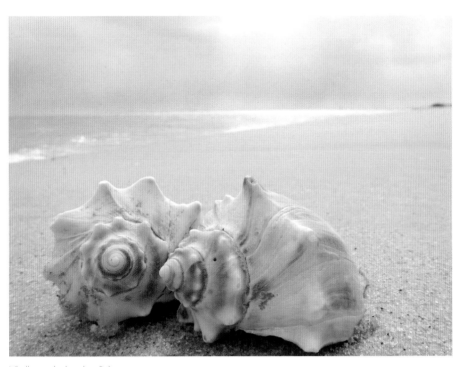

Whelks on the beach in Delaware.

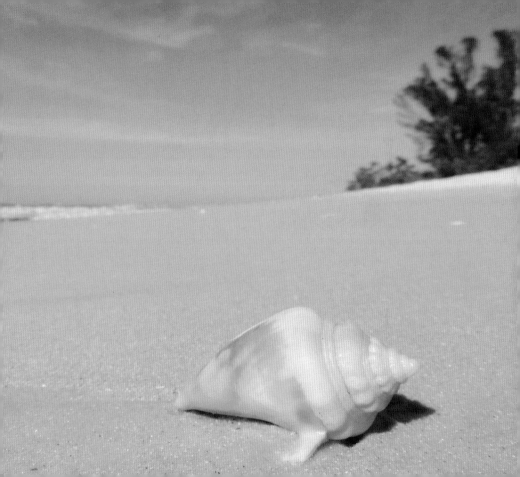

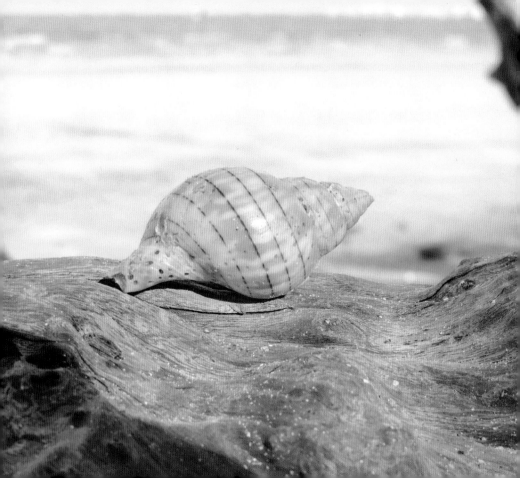

YOU CAN GET A visual of dextral or sinistral aperture if you hold a spiral shell so that the pointed tip (known as the *apex*) is pointing upward and the opening is facing toward you. By holding the spiral shell this way, you can determine on which side the aperture sits.

Occasionally a shell will show its renegade spirit by spiraling the opposite way it's naturally supposed to, making these specimens rare and much sought after by shell collectors.

Tulip shell

59

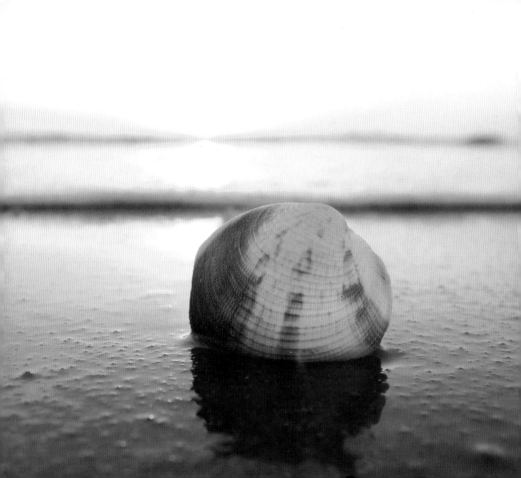

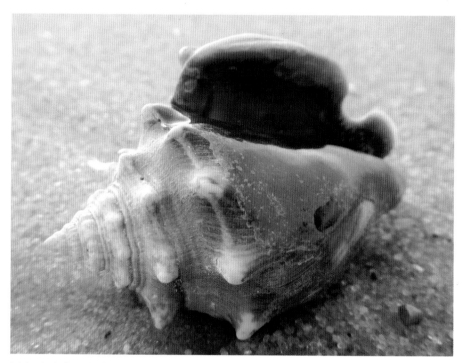

Delphinula shells can be found in areas of the Indo-Pacific.

WHEN I DUG OUT my shell collections and spread them out on the floor to examine, I was amazed. The shells from my honeymoon in Aruba looked so exotic! The ones I collected in Maine didn't look anything like them. Have you ever wondered why shells from different regions look different? The shells found in colder waters, like in Cape Cod or Maine, for instance, tend to be plain, without a lot of coloration or decoration. Their counterparts in warmer waters, such as in Florida and the Caribbean islands, are just the opposite; some are downright resplendent! A lot

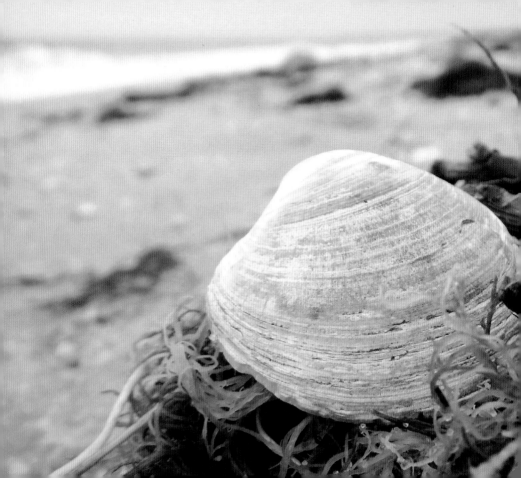

of people consider the tropical water shells prettier and thus more collectible. I love those I've collected in Florida and Aruba, but I also really admire the shells I picked up in New England. The quahogs, mussels, and scallops are provincial, ever so charming, and beautiful in their own right! They are humbly weathered by the cold, churning waters of their environment, and I believe they are full of character like this rustic, whitewashed clam.

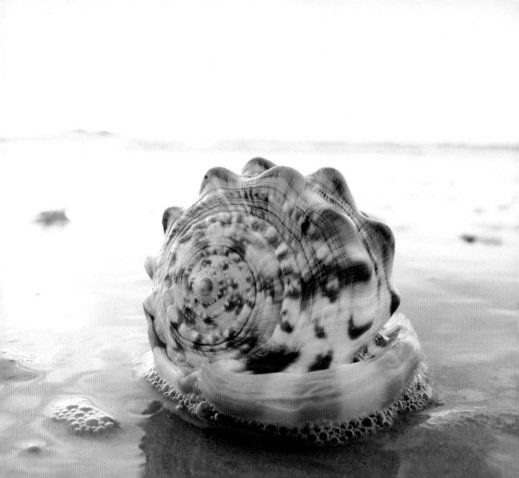

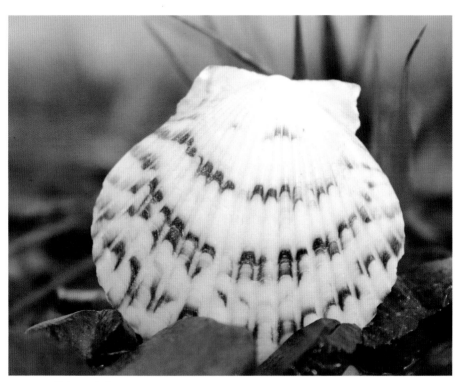

opposite: Helmet shell

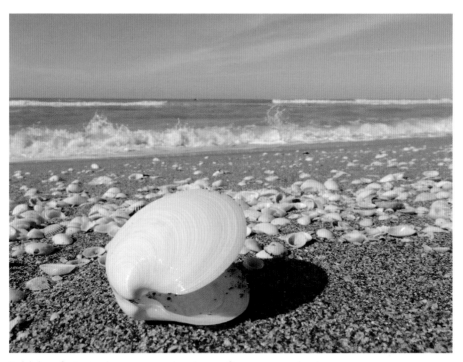

Both halves of a Dosinia clam are intact and just begging for me to snap a photo!

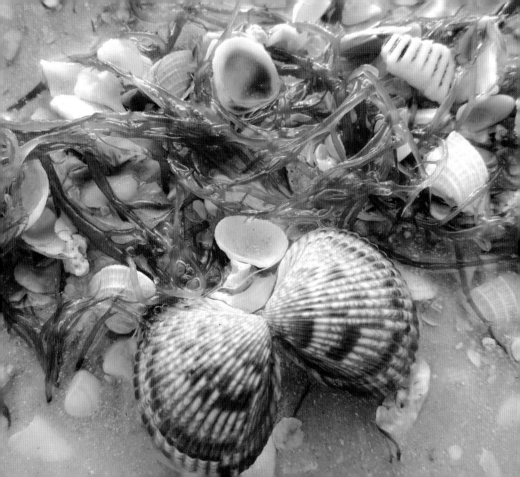

Jingle shells can be found in colors
that range from yellow to gray
to orange.

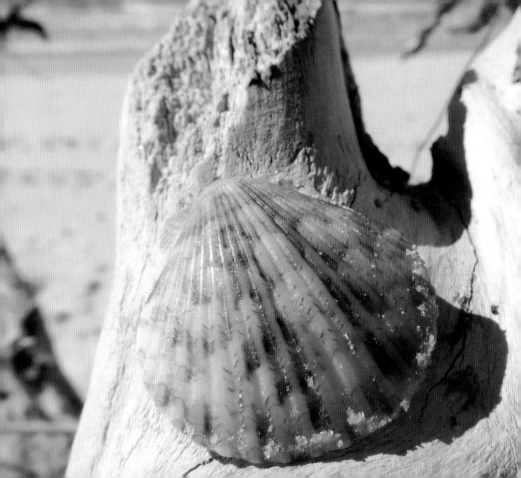

ONE OF THE FASCINATING aspects of shells is the way the environment affects their appearance—especially with regard to water temperature. The warmth of tropical waters supports a greater variety of life than colder waters , which makes it a very dangerous place. Protection is always key: through

Atlantic calico scallop

75

evolution, each mollusk has developed its own unique way to keep safe. Some have grown spikes and protrusions to make capture more difficult; some have developed smooth, shiny outer shells to make themselves slippery and difficult to catch; some have thick ridges that add strength; and others have developed shapes that allow them to easily burrow under the sand to hide. All of these attributes make their shells beautiful for us to look at and collect, but for each mollusk that beauty helps it fight for its life!

What about the colored patterning found on seashells? It turns out that this aspect of the seashell has been a bit of a mystery for scientists, especially since the patterns are so varied and complex among the thousands of species. For years, experts have tried to come up with a definitive explanation as to why and how the patterns are created. What they've been able to determine is that the mollusk's nervous system sends signals to the cells located in its mantle, which then stimulates a secretion of pigment in a certain amount and direction,

opposite: I was enjoying an early morning walk in Cape Cod when I spotted a few shells and some seaweed. All I had to do was inch the shells closer to the seaweed so I could capture the gorgeous colors of the sky along with those on the sand.

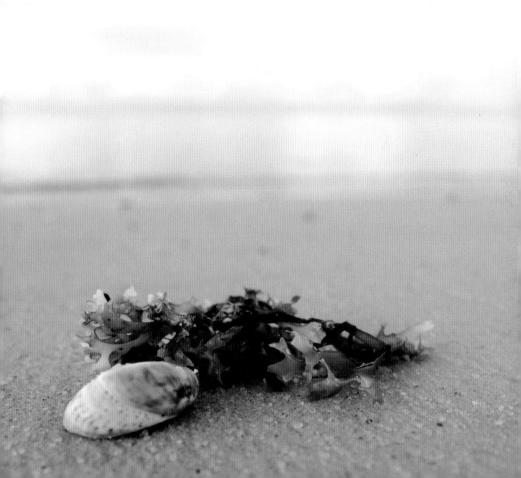

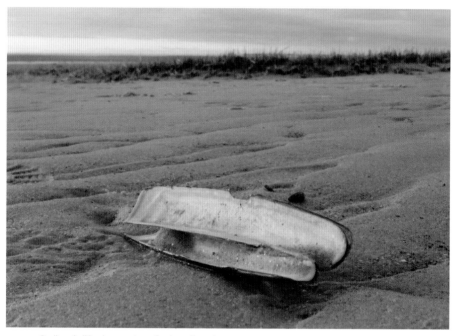

opposite: Scallop shell basking in the soft glow of a pink sunset.

above: The pearly white nacre inside this razor clam gently reflects the colors of the twilight sky.

resulting in a pattern. It's thought that the pattern helps the mollusk know where it left off in the shell-making process. The theory is that the mollusk needs a way to figure out where to put its mantle when it begins to make its shell larger since shell growth happens in spurts instead of at a steady, continuous pace. The pattern is essentially a physical record of the growth and life of a mollusk! If you study a shell closely you may be able to tell if it was attacked and damaged, and sometimes you can even see where it did repair work on itself.

Shells and the mollusks that make them play an important role within the ecology of the marine environment. Mollusks provide food for a great many of the creatures found in and around the ocean and

Oyster basking in the citreous light of the beach.

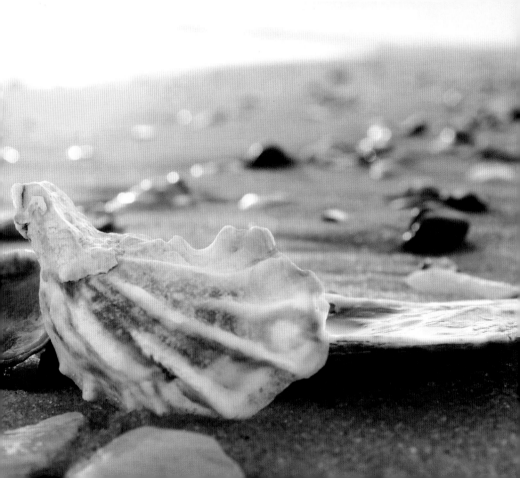

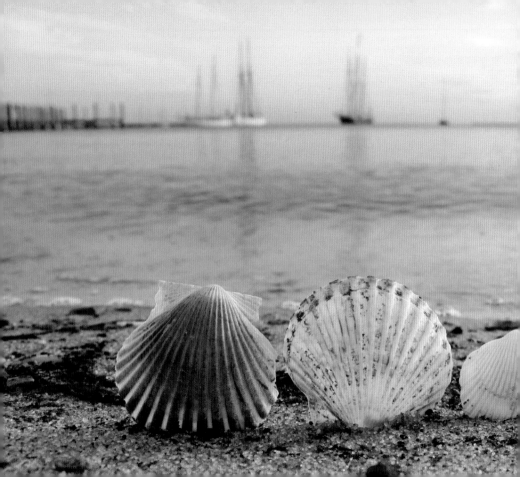

are a necessary member of the food chain. Also, discarded shells go on to provide nesting materials for shorebirds or new homes for other creatures like hermit crabs. Shells also provide a home base for barnacles, algae, seagrass, or larvae that attach themselves to their surface. Leigh, a marine biologist I met during a trip to Florida's Sanibel Island who leads nature walks on the beach, explains it like this: "Nothing in the ocean goes to waste. Eventually it will be of use for something!"

Over time, layers of shells and shell fragments can help to lessen beach erosion. Shells are also a source of organic deposits of calcium carbonate under the water, where the layers of shells accumulate to eventually form sedimentary rock called *limestone*, which is used as a construction material.

Scallops and an ark shell right at home in New England.

83

Mussels, oysters, and clams play an important environmental role because they can actually improve the quality of water. Most bivalves are considered filter feeders. This means that they are constantly circulating water through their shells to obtain their food supply. Clam aquaculture provides a beneficial ecosystem service of water filtration—a single clam can filter 4½ gallons of seawater daily, removing harmful nitrogen from coastal waters while storing harmful carbons. There are currently numerous projects underway in the United States that use mussels and oysters to improve water quality naturally.

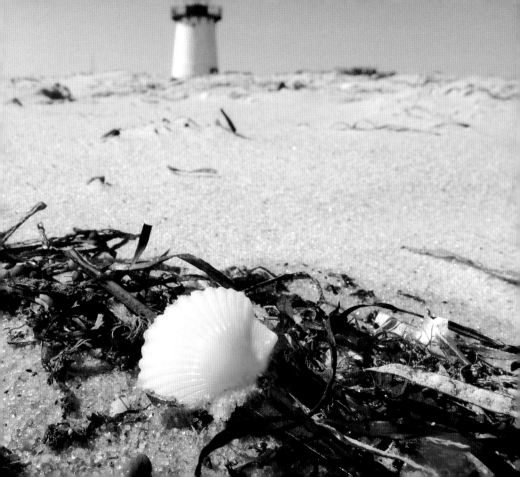

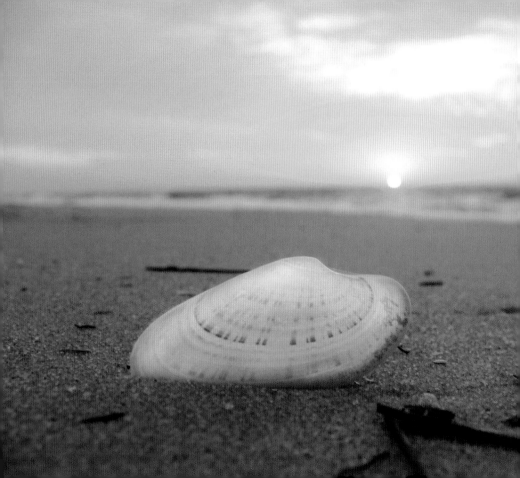

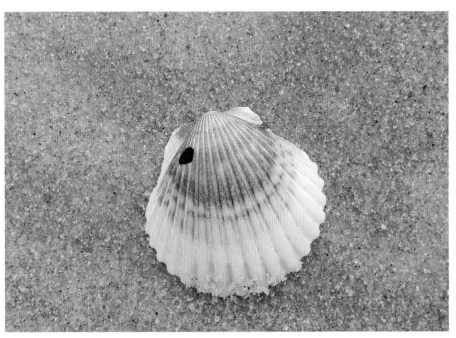

opposite: Sunray venus

above: Notice the circular hole in this scallop, most likely made by another gastropod.

WHEN I'M BEACHCOMBING I seem to be drawn to those shells and shell fragments that are pearly and shine with iridescence. Often I'll stop just to marvel at the shimmery colors that bring to mind the glow of the aurora borealis. Move these shells to change the angle at which the light hits them when they're wet, and the colors produced can truly be amazing. This is the nacreous layer of the shell, otherwise called *mother-of-pearl*, and it is sometimes visible if you peer inside a shell. Sometimes the bits of shells we find on the beach have been weathered and eroded right down to this inner layer so that we get to enjoy the gleaming light show! The nacre layer is formed by many diagonal layers of calcium carbonate crystals and proteins that overlap each other, and the rainbow colors are the refraction of the light off the edges of the slightly off-kilter layers.

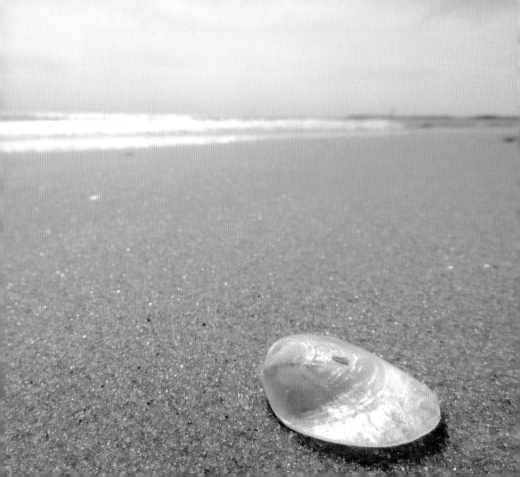

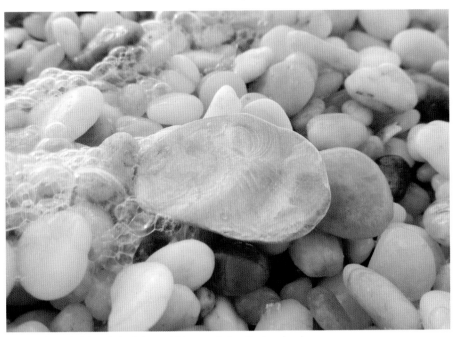

opposite: I can't help but think of the word "shimmery" when I look at this photo.

above: The exposed nacre layer in this bit of shell is a stunning cantaloupe color.

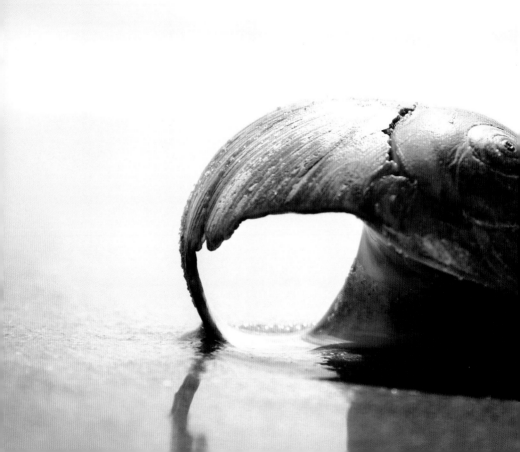

THIS AMAZING SUBSTANCE IS more than just pretty—it is also very strong, and for a good reason! If a mollusk were to be captured in the clenches of a crab, for example, the cracking that would occur in the outer layer of the shell would be contained once it reached the nacre layer and wouldn't extend down further to injure the mollusk. In fact, the strength of this layer has fascinated scientists for years and inspired a great many scientific studies. Scientists have learned from it how to make glass and ceramics stronger, and these results could someday inspire new building materials for the military and aeronautics industries and maybe even the health field. It's thought that scientists may even be able to use what they learn about nacre to replace or repair bone with a new, very strong ceramic substance.

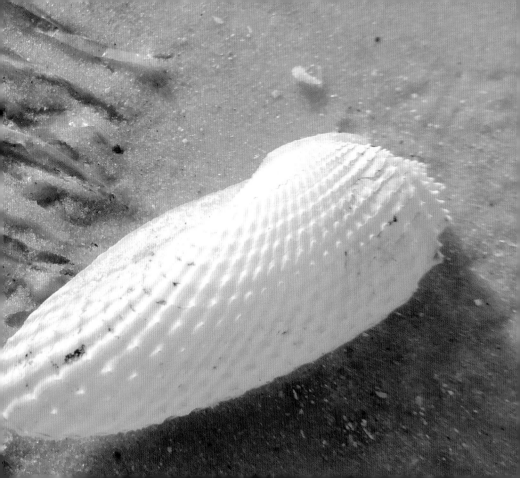

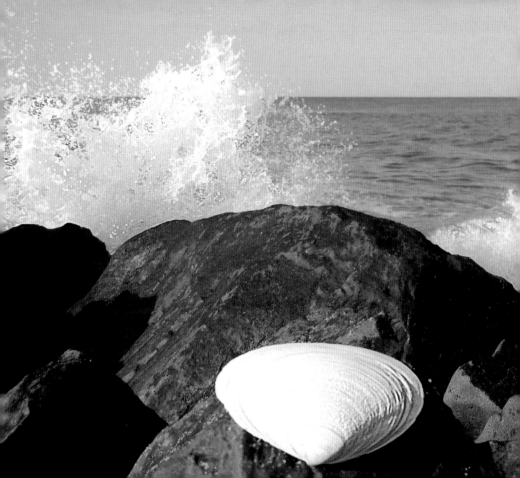

I was surprised to discover that these aren't the only areas of study that have been inspired by seashells. It has been really eye-opening for me to discover the many important and interesting contributions seashells have made to our society over the years. Here are some of the more interesting ways shells have been useful in the past and new ways on the horizon that I think you'll appreciate.

In 1500 BC, the Phoenicians discovered that the *Murex brandaris* (known more simply as *murexes*)— a type of mollusk with a shell that resembles a small whelk with short, raised points on its ridges—could be used to produce a beautiful purple-colored dye for fabrics. It took thousands of these mollusks to produce even a tiny bit of the dye. As a result, only

Will a wave sweep away this clam before a seagull has a chance to peck at it?

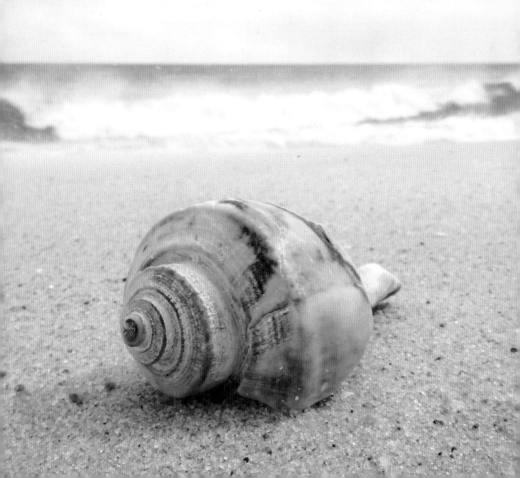

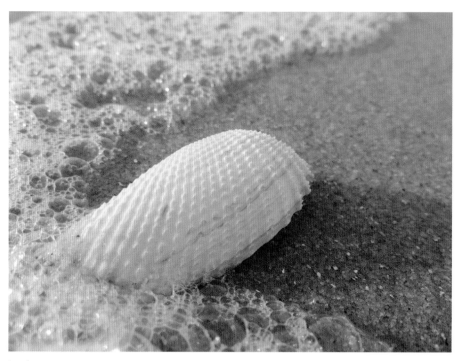

Angel wing

the very wealthy could afford to wear garments in this color. Back then, if you were looking gorgeous, all decked out in your purple clothing, people knew you were *very* wealthy and most likely a member of royalty! It's interesting that, after so much time, there's still an affiliation between prestige and the color purple—even now this color is often associated with royalty.

The mollusk of the cone shell has a powerful venom that has greatly motivated scientists to study it, and what they've discovered has positive implications in the medical field. The interesting and unusual thing about this mollusk is that it protects itself against predators with a paralyzing, lethal sting. The scientific community is very intrigued by how

This old whelk may be sun-bleached and weathered, but its muted colors are very pretty.

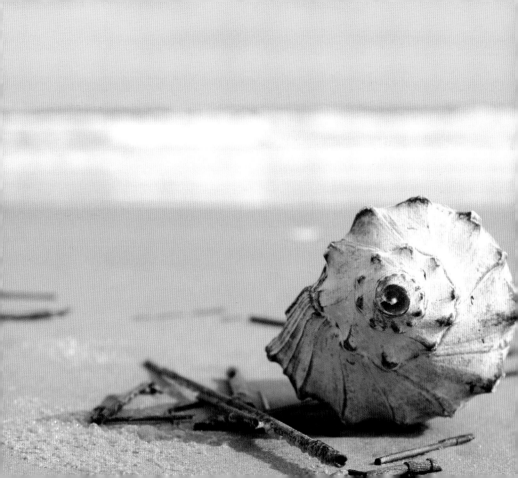

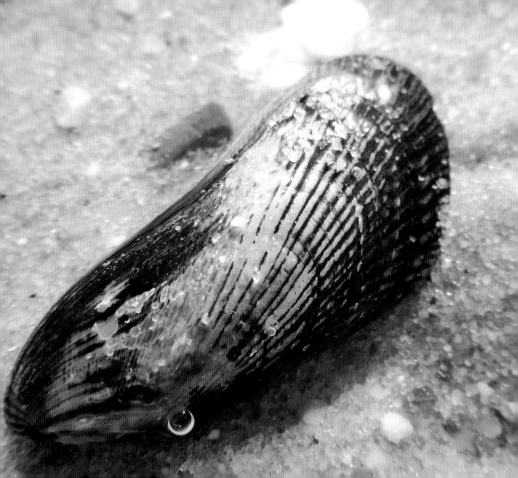

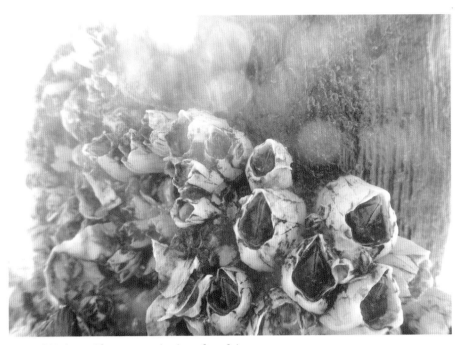

opposite: Ribbed mussel floating just under the surface of the water.

above: Barnacles growing on a stump of wood are exposed at low tide.

effective this sting is, and through numerous studies they've been able to re-create those compounds and are now using them in medicine to create powerful but safe pain relievers. It sounds like studies in this subject will continue because exploration of this substance has such merit.

Mussels secrete a sticky substance that's strong enough to keep them attached to the rocks along the shore in their natural habitat, even in the strongest of water currents. This has inspired many scientific studies seeking to use the knowledge in the manufacture of effective adhesives for various industries, especially for underwater and surgical applications.

The clusterwink, found in Australia, is a unique shell with an amazing talent! This shell actually

Channeled whelk

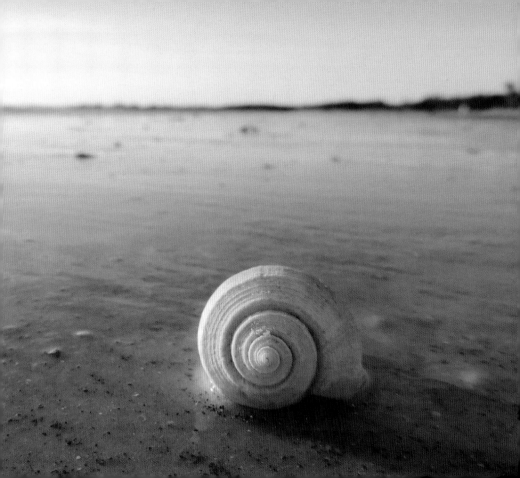

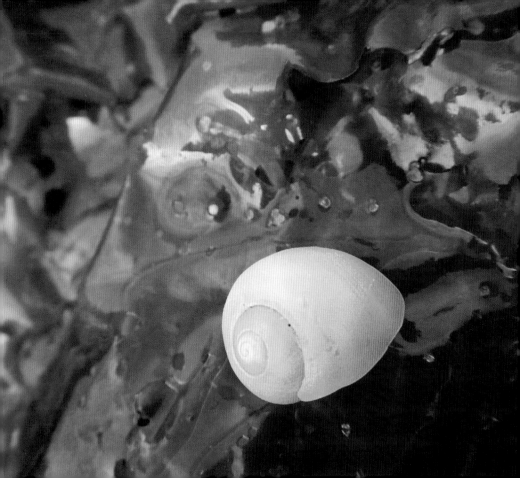

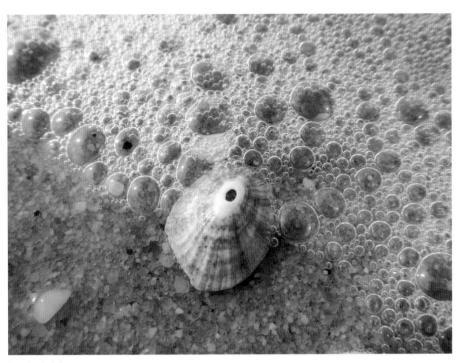

Rosy keyhole limpet

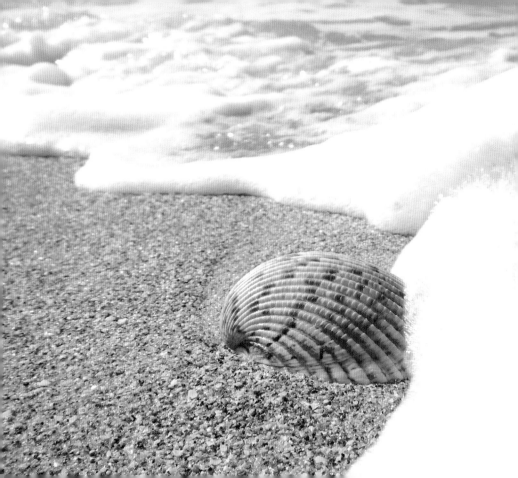

lights up! It produces bioluminescence that creates a glow of light as a form of self-defense. It's actually the mollusk inside the shell that produces the glow, but the shell around it is thin enough to act as a diffuser so that the whole thing glows with a green light. It's really the bioluminescence that interests scientists—they're still not totally sure how the whole process works, but they believe their studies could eventually yield advances in the optical industries.

In the jewelry and art worlds, shells have given us an abundance of beauty and inspiration. The nautilus shell has inspired the design of the decorative spiral staircase, and in the French rococo era, shells were used as a focal design element with beautiful results.

Cockle shell about to be swept up by the tide.

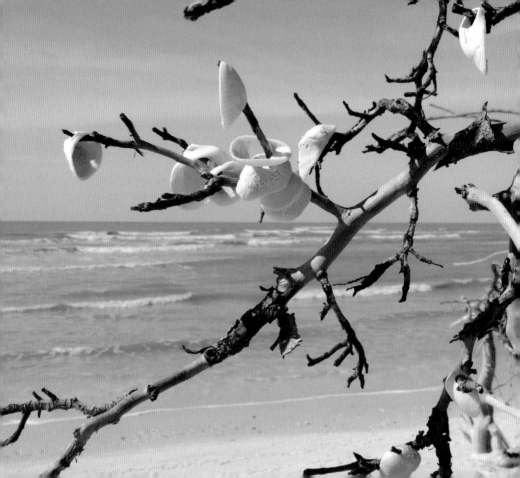

In the jewelry world, shells have been used very successfully to create wearable works of art. My favorite example is wampum, which is a type of bead carved out of quahog clam shells. These beads show off the white and purple striations found naturally in the quahog clam shells and are a traditional form of jewelry made by generations of the Wampanoag Tribe in New England (mostly in Massachusetts, Rhode Island, and Connecticut). Originally made prior to the arrival of Europeans in the region, this jewelry often had religious significance. After settlers arrived, wampum was then used as a source of currency in trade between the Wampanoag and the settlers. This art form is being revived today, and one can find

In southern Florida it's possible to find driftwood, old mangrove stumps, and trees uprooted from storms beautifully decorated with shells courtesy of many beachcombers. I think it's a lovely tradition.

gorgeous examples of jewelry made by very talented artists. It's worth the time to look up wampum artists online if you are very much into seashells!

During the Victorian era artists actually made jewelry out of the operculum part of a shell because it resembles a cat's eye. With a teal green circular stain of color that fades out to white on one side and a soft pastel peach color on the other, this jewelry was quite a popular fashion statement at the time. It was derived from the tapestry turban shell (found in the Mediterranean). Because the operculum from this particular type of shell is thicker than most, it could easily be made into jewelry.

Of course, you can't discuss shell jewelry without mentioning the pearl! Bivalves such as oysters, mussels, and clams produce pearls. Because bivalves are filter feeders that circulate water through their shells, natural pearls are formed when an object or parasite settles inside, causing many layers of nacre to be formed around the object as a form of defense. There are two kinds of pearls: natural pearls, formed without human intervention in a wild oyster, and cultured pearls, which are genuine pearls whose formation was initiated by humans.

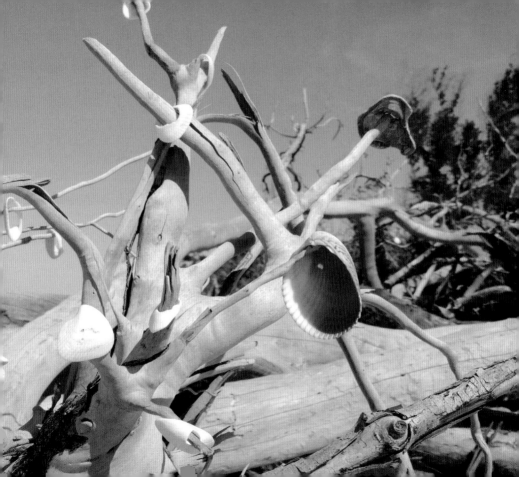

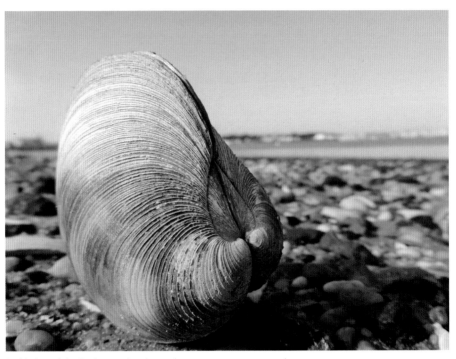
Both halves of this bivalve are closed up, making a very interesting visual.

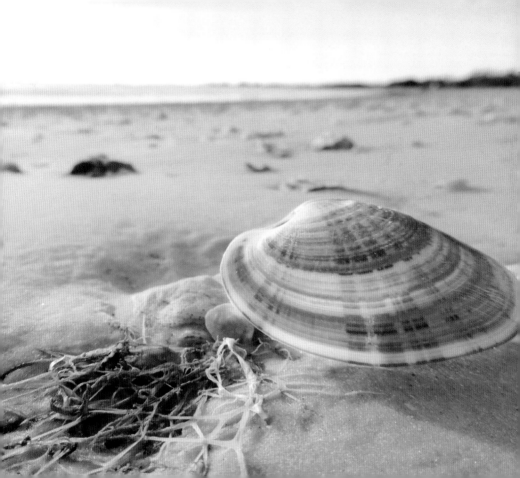

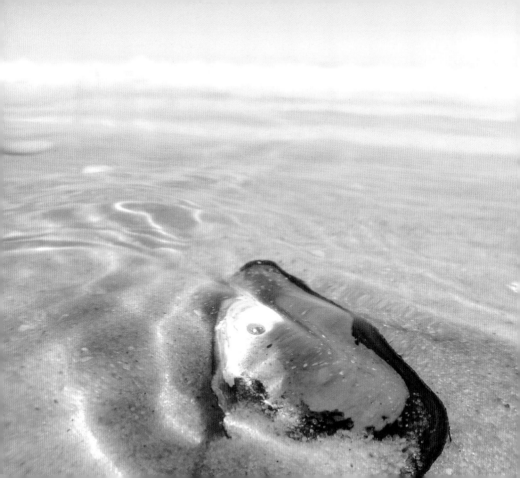

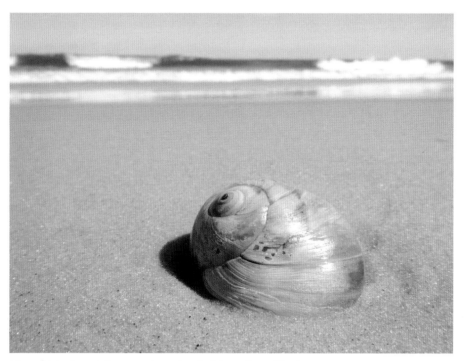

A beautiful shark eye shell sitting in the sand at the Delaware National Seashore.

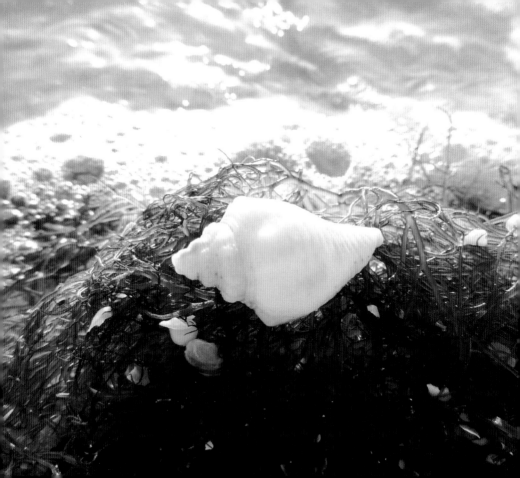

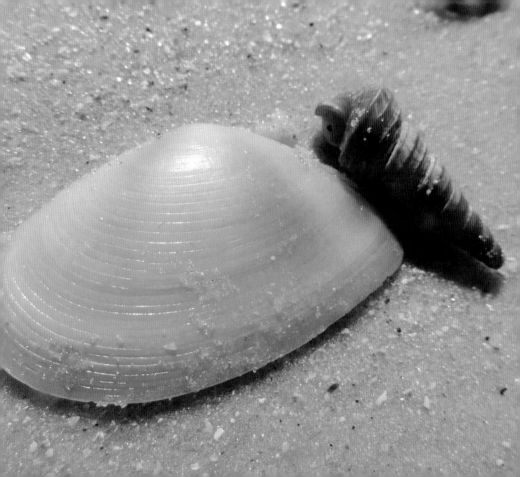

NEXT TIME YOU GO to the beach and a shell catches your eye, you'll understand there is so much more to this object than its sheer beauty. Each seashell once contained a living creature whose life history is recorded within the shell material like a diary. Its ornamentation or lack thereof tells the story of where it lived, how it protected itself, and whether its environment had cold water or warm. Its coloration tells the story of its diet and what it ingested. Its patterns and decoration show its history of growth. Sometimes you can see the repair work each mollusk has done to its shell, left behind like a battle scar. The shell's size tells us the general age when the mollusk died (because we know the mollusk will never be without its shell).

Bright, colorful rose petal tellin.

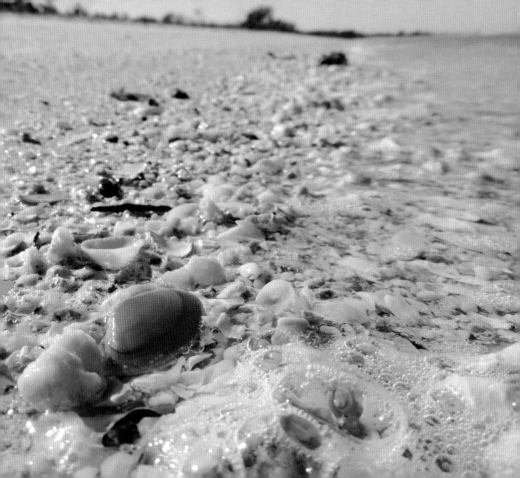

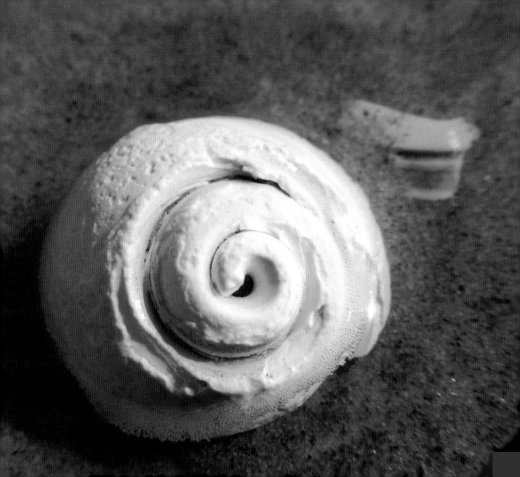

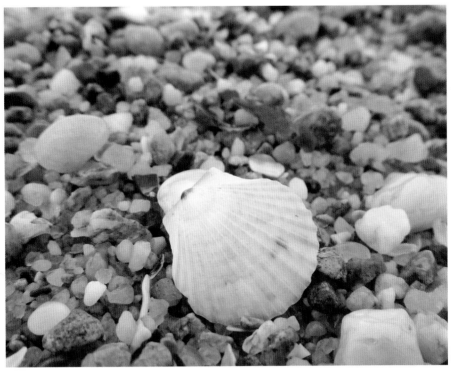

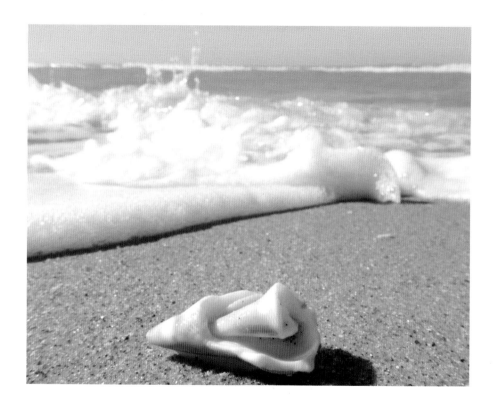

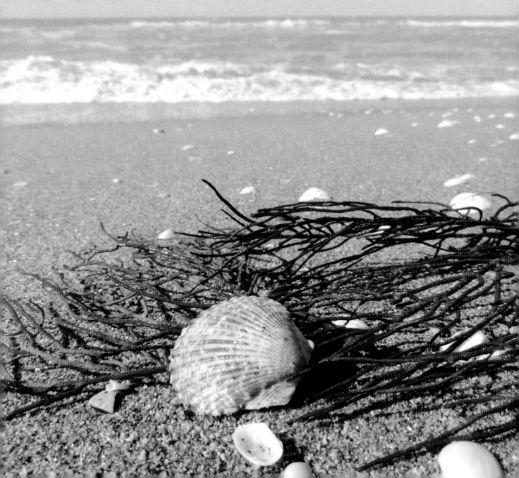

The humble shell will continue to inspire important work in the sciences, guiding us to make discoveries and important advances, and to create new inventions. As an inspiration for the arts, the shell speaks for itself. Its beauty is enthralling! And a shell can simply serve as a reminder of some of our best days spent at the beach. Be a shell seeker! It's relaxing and can provide you with the perfect excuse to escape for a peaceful reprieve and a chance to connect with nature.

May the seashell forever reside in our collections, proudly upholding its important message that nature is amazing, beautiful, and often symbolic. The simple shell can remind us that in a world of thousands, each individual is unique, different, interesting, and important, and that this is exactly what makes *us* beautiful!

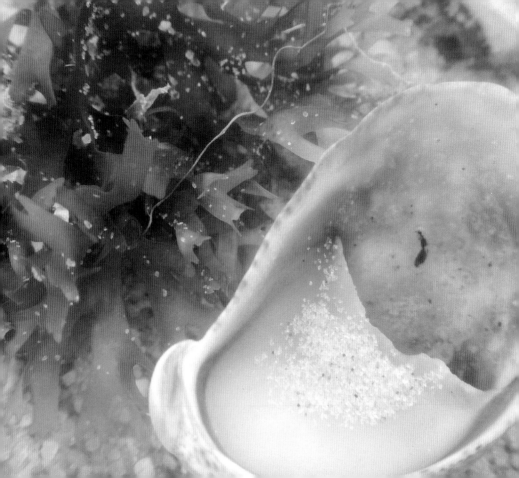

An oyster in moving water.

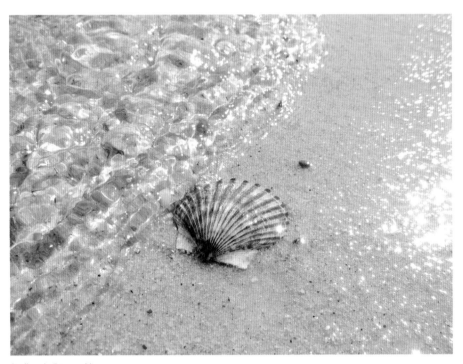

Scallop shell in sparkling water.

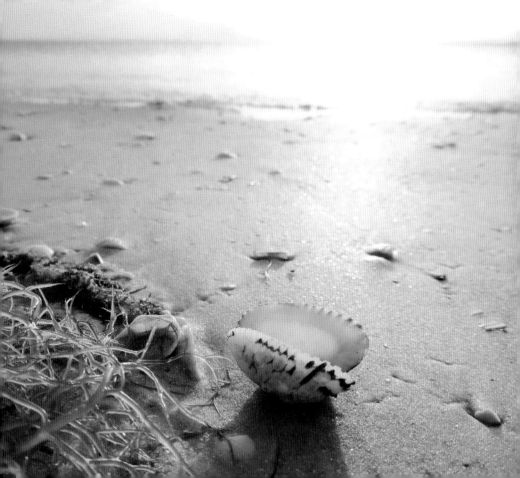

MY STYLE OF PHOTOGRAPHY puts me close to sand and water—two of the worst things for camera equipment! In an attempt to preserve my cameras, I keep them (all three) in a backpack that I wear while I'm shooting, and even then I've still managed to damage some equipment. I've had to get cameras repaired and even had to replace one, yet still I persist in taking them as close to the sand and water as possible. Sheepishly, I've walked away from photo shoots at the beach in the middle of winter after a pounding by a rogue wave when I wasn't paying attention. Bystanders must have thought I looked crazy with all that wet sand caked onto my jeans! But I love photographing the beach this way and will continue to challenge the elements. I love every minute of it!

above: The water receding at low tide in Cape Cod, revealing a tiny mud snail.

opposite: I thought the undulating patterns of the soft sand were alluring, and it seemed like this shell was taking in the scenery like I was.

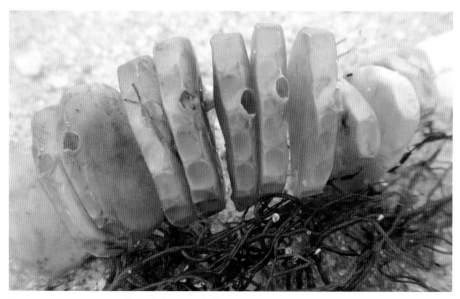

This is a string of egg casings from the knobbed whelk. Encased inside each disk are tiny hatchling whelks. The holes you can see on the disks indicate that the young snails have left the egg. Usually the first few disks of a string will remain empty, and these will be buried in the sand on the ocean floor to be used as an anchor that holds the string in place.

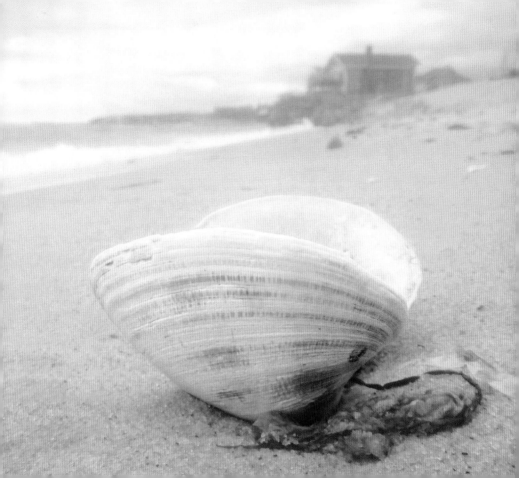

Beachcombing Tips for Finding Shells

- Try to plan your visit to the beach at low tide. I suggest using this website to determine when low tide will occur in your area of interest: NOAA Tides & Currents (www.tidesandcurrents.noaa.gov).
- Stormy weather can wash up a greater number of empty shells. Try to visit a beach after a storm for better luck.
- Don't forget to look through piles of seaweed you see on the beach.
- Leigh from the Bailey-Matthews National Shell Museum (an awesome place on Florida's Sanibel Island) suggests that the best way to spot shells is to look at the top of the sand rather than brushing or digging away at it.
- Barrier islands often provide great beachcombing.
- Keep trying! Beaches change constantly—no two beachcombing trips will be alike.

- Try wading in the low-tide zone in the first few feet of water to look for shells. Just be aware that some beaches have severe drop-offs, so don't go out too far if you're unfamiliar with a particular beach's topography. If the weather is chilly, a good pair of waterproof boots comes in handy!

- If you enjoy snorkeling, this is a great way to look for shells that haven't washed up yet. Be aware that some will have live creatures inside, so be vigilant about only keeping empty shells.

- A shell-seeking trip may be in your future if, like me, you don't live in Florida, because Sanibel Island is famous for its seashells. I highly recommend a visit!

- Don't get discouraged if you don't find shells at a particular beach. Nature is unpredictable, and while one beach may not have many shells, the next beach may indeed have lots. This has happened to me, and I was rewarded when I didn't give up.

- A tip I've found useful: note on a small slip of paper the date and location you collected your shells and keep it with them for future reference, when you want to remember a special trip. You can store the note in a small decorative jar or just keep it in a zip-top bag.
- There are a few great website resources for people interested in seashells: www.iloveshelling.com, www.conchologistsofamerica.org, and www.shellmuseum.org.
- Ethical shell collecting: When beachcombing for shells, it is important to only take home empty shells. The mollusk living inside the shell cannot survive without it.
- Try not to collect too many spiral-type shells. Hermit crabs need this kind of shell for their home, so after you decide on your favorite one, you'll want to leave the others behind. Hermit crabs don't make their own shells like most other mollusks. So, each little guy's life depends on finding an empty shell to burrow in for protection. And as a hermit crab grows larger he

must vacate the shell he's grown too big for and search for a larger, shell that will fit him. Large shells that are whole, empty, and in good condition are rare and hard to happen upon, so it's important to leave some behind. If you consider that there are more than a thousand different species of hermit crabs worldwide, all needing empty shells of various sizes, you can understand this little guy's plight.

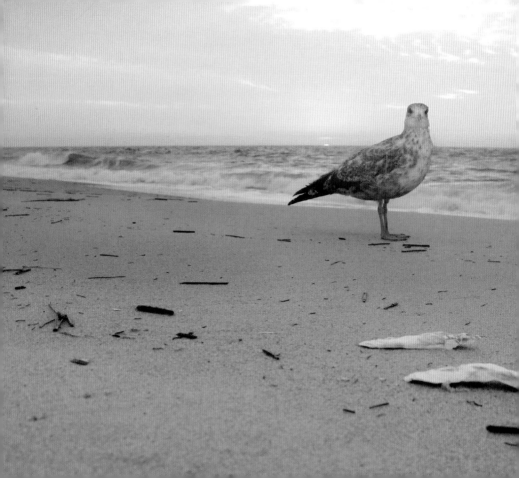

Further Reading

Mermaid's purses:
www.sanibelseaschool.org/experience-blog/2014/5/23/what-comes-out-of-those-mermaids-purses

Shell science applied:
www.technologyreview.com/s/411301/ceramics-that-wont-shatter/

motherboard.vice.com/en_us/article/z4m8k5/the-amazing-snail-shell-science-inspiring-tomorrows-toughest-materials

www.chemistryworld.com/podcasts/nacre/8561.article

owlcation.com/stem/Cone-Snails-Dangerous-Venom-With-Medicinal-Uses

www.engadget.com/2017/03/13/shellfish-inspired-underwater-glue/

www.popsci.com/article/science/mussels-inspire-glue-works-underwater

www.livescience.com/10909-sea-snail-glows.html

phys.org/news/2010-12-scientists-bizarre-bioluminescent-snail.html

I think this guy wants me to leave his shells alone . . .

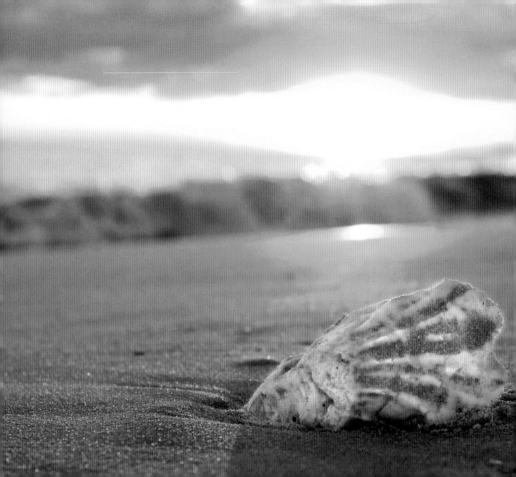